SPEAKING
IN TONGUES

SPEAKING IN TONGUES

curious expressions from around the world

ELLA FRANCES SANDERS

◻ SQUARE PEG

· INTRODUCTION ·

*Welcome to the logophiles and the linguists, to those who speak
one language and to those who speak in many tongues,
to the older and the younger, to those with high expectations
and even higher dreams, to those who don't know quite where they are yet,
to those who have picked up this book not knowing quite what it is . . .*

Speaking in Tongues is your introduction to some of the world's strangest and most wonderful expressions. I say 'introduction' because this book would need to be thousands upon thousands of pages long (and several volumes after that) to include all the curious, magical and transcendent sayings we use to express ourselves. It is a beginning; for you and for me.

The fifty-two proverbs, expressions and idioms in these pages will perhaps give you new ways of thinking about the world around you; hopefully, they will breathe some magnificent life into the everyday – colour the view slightly differently so that you might be able to see the previously unseen. Most of these sayings refer to the natural world in some way – the landscapes and creatures and vegetables alongside which we have evolved – and this says an awful lot about how we have made sense of things in the past and how we make sense of things now – whether the saying is from a Scandinavian language or an African one. We cast our line into the blue depths of the languages that we know, hoping to catch the right words, and reel them back into our heads so that we might be able to unfold a situation or happening with understanding and insight.

There is a quote that I cannot forget from Brandon Stanton's photography project and subsequent book *Humans of New York*: 'I'm learning to be more careful with my words. Words that seem meaningless at the time can end up having a lot of power. Seeds that you didn't even intend to plant can fall off you and start growing in people.'

The imagery that accompanies this quotation has been stuck in my head since I read it, and that handful of words has sat with me, patiently, throughout the creation of this book. I can no longer simply think of language in terms of letters and words; rather, I think of it as tall plants and tiny seeds and flowering vines that grow slowly but surely around us as we wander through this world trying to learn how we should live.

The sayings in this book are like plants that have, in many cases, been growing for centuries, passed down from one generation to another, grown through one community to another. They have helped us to understand ourselves and others – events that we live through together and the events that we live through alone. The expressions you will find between these pages have shaped and been shaped by diverse people and cultures. They have given us relief, given us reason to laugh, given us ways to describe both the mundane and the profound minutes from which our lives grow. They speak of birds and honey and lakes. Dancing bears and broken pots. Sponge cake and clouds and radishes.

These expressions are ageless, tireless. Subject to change but immortalised in memory.

And they are now yours.

FRENCH

The idea of this is completely ridiculous – why on earth would anybody be pedalling their bicycle through sauerkraut? Used in the intellectual sense, the idiom means to be at a complete loss or to have lost the train of one's thoughts. Used in a practical sense, it can mean that something is no longer progressing and is ineffective, that the wheels are spinning. Unlike many odd idioms, this one's content is actually related to its origin – it comes from the early Tour de France races. The broom wagons – the vehicles that follow cyclists and pick up stragglers or those who are unable to finish the race within the allotted time – often featured billboards advertising sauerkraut.

pédaler dans la choucroute

TO PEDAL IN THE SAUERKRAUT

DUTCH

This means 'She has long legs'. In researching the etymology of the Dutch word for 'magpie', it's clear that the word has been through a considerable number of forms, with some referring to its sharp beak, others to its long, pointed tail. The magpie is widely considered either an ill omen or a good one depending on where you are in the world: in China, the bird is a lucky sign; in Mongolia, it is believed they have control over the weather; in Scottish folklore, they foretell death; and in German folklore, they are thieves.

Something else that elevates magpies into the ranks of the intriguing: they are one of only a few types of bird that hold funerals – when a magpie dies, others will squawk loudly until there is a whole conventicle of magpies gathered at the scene, at which point they will all fall silent for a few seconds.

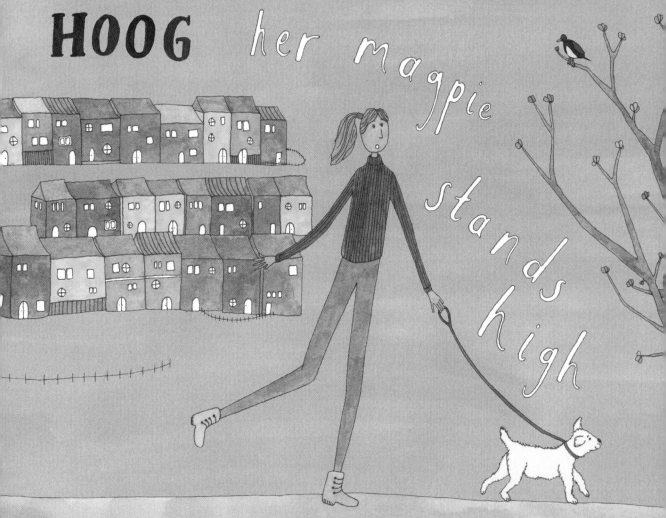

HAAR EKSTER STAAT HOOG

her magpie stands high

JAPANESE

Even monkeys fall from trees? Nonsense. Why would a monkey ever fall from a tree? Well, this saying (one of the most well known in the Japanese language) is a way of pointing out that everybody gets it wrong sometimes, that even the cleverest among us, the most skilled, the most practiced – they still make mistakes. It's an excellent way to keep overconfidence in check. A good example of this can be found in figure skating – even the athletes who have been training day in and day out for years will still, inevitably, fall on their face at some point. Actually, this neatly ties into the German expression *Schadenfreude*, which is the delight we can feel at someone else's misfortune (if you're into that sort of thing).

猿も木から落ちる

even fall monkeys from trees

KOREAN

Does the pear fall off because the crow flies away? Or does the crow fly away because of the falling pear? This expression means that two incidents, two seemingly connected coincidences, don't necessarily mean causation – one is not always related to the other, and they may well be entirely separate happenings. But such situations don't stop us from speculating because it's easy for our brains to tie things together with meaning when they coincide so perfectly. False correlation is such a big deal – in finance, in politics and especially in philosophy – that there are even fancy names for it: apophenia or patternicity. In a nutshell, we have a tendency to find meaningful patterns in meaningless information.

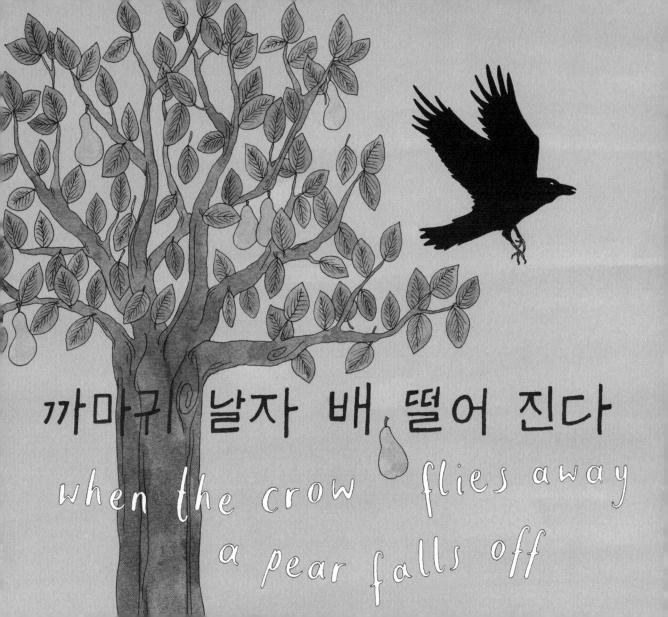

까마귀 날자 배 떨어 진다

when the crow flies away

a pear falls off

SERBIAN

If you are ripping clouds with your nose, then you are puffed up, conceited, even vain. The assumption here is that you are a) walking around with your nose sticking up in the air and b) you think so much of yourself that you have somehow ended up at cloud altitude. It is both bizarre and wondrous in equal measure when you peer closer at idioms from other languages and Serbian has some great ones, such as 'I didn't fall from a pear tree' (*Nisam pao s kruške*), the equivalent of 'I wasn't born yesterday', and their version of 'When pigs fly', which translates to 'When grapes grow on willows' (*Kad na vrbi rodi grožđe*).

NOSOM PARA OBLAKE
he's ripping clouds with his nose

JKL

HUNGARIAN

This is a (vaguely) polite way of saying that someone knows jack squat about the thing in question, that they don't really have a handle on things, and therefore will probably not be a good source of information. A Japanese proverb says, 'If you wish to learn the highest truths, begin with the alphabet.' But hens – not usually seen to be founts of the highest truths – obviously do not know very much about the alphabet. However, chickens are quite clever, incurably curious birds. They will follow their humans around, watch them do the gardening or hang out the washing, and generally play overseer to many an occasion. So perhaps it is fortunate they haven't learned to read, because they would surely find this particular saying a bit insulting – they hold their beaks high.

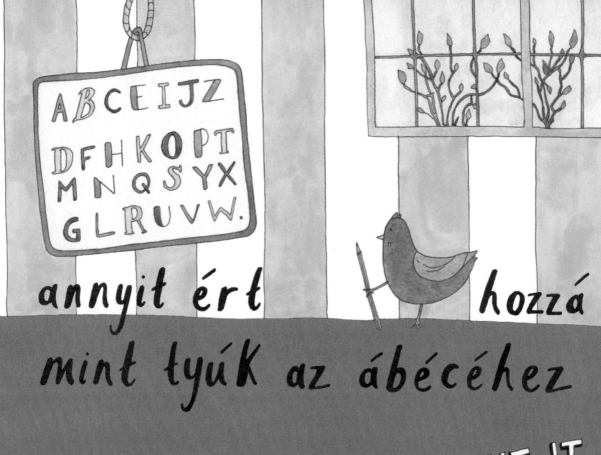

annyit ért hozzá

mint tyúk az ábécéhez

HE KNOWS AS MUCH ABOUT IT
AS A HEN KNOWS ABOUT THE
ALPHABET

LATVIAN

If you're blowing little ducks, then you are talking a load of codswallop and nonsense, or are telling lies. So logically, if someone in Latvia tells you to 'blow little ducks', it means that they can see right through you and know that you are not telling the truth. A Baltic language, Latvian is most closely related to Lithuanian, although there are two other languages spoken in the country, Latgalian and New Curonian, which are so similar to Latvian that people like to disagree about whether they should be separate languages or just dialects. Baltic languages (the only two still spoken today are Latvian and Lithuanian; the others are extinct) are of special interest to linguists, because it is thought they still contain archaic elements and features that were present in a language spoken around 3500 BCE, which was the common ancestor of Indo-European languages.

PŪST
PĪLĪTES
to blow
little ducks

PORTUGUESE

This idiom is definitely not alone – it is in good company among the idiomatic English phrases 'To cast pearls before swine' and 'Giving caviar to the general'. This expression and its cohorts centre on the senselessness of giving something magnificent to someone who will not, or cannot, appreciate it, and of treating someone really well when thecy don't deserve it. After all, why would you feed a donkey sponge cake when he is unlikely to fully appreciate its light, fluffy texture, or the sharp tang of the jam in its centre? Portuguese donkeys don't have a great time of it; they are also told they cannot learn new languages when they're older (*Burro velho não aprende línguas*), the equivalent of not being able to 'teach an old dog new tricks'. No cake, no languages.

Alimentar um burro a pão de ló

TO FEED A DONKEY SPONGE CAKE

SPANISH

To call someone your orange half is to refer to them as your soul mate or the love of your life (in an informal, affectionate way), and it's a widely used term of endearment. Why use a citrus fruit for a term of endearment? What could possibly be endearing about an orange? Well, one common theory is that because no two oranges are the same, there is only ever one match for each orange half. Another traces the term back to ancient Greek literature and Aristophanes speaking of the notion that humans were originally man-man, man-woman, or woman-woman and that one day, Zeus split these doubles in half, leaving us with an ongoing, sometimes fruitful search for our other half ever since.

FINNISH

In this saying, the cat in question is pacing around the porridge because, although he would like nothing more than to get his paws in the oat-filled, milky bowl, he doesn't dare because the porridge is too hot; instead, he just walks around and around wondering why time is moving so slowly. In human terms, this saying refers to someone who is incredibly curious about something or badly wants to say or do something but just can't quite get there yet. Perhaps they chicken out a little or (frustratingly) have to wait for the right time to act. It's reminiscent of the English idiom 'To beat around the bush', which is similarly used to mean trying to delay or avoid getting to a point.

KIERTÄÄ KUIN KISSA KUUMAA PUUROA

to pace around hot porridge like a cat

GERMAN

There are many idioms relating to death and they say a lot about how we process and make sense of it. Logically (as is always the case with German), if you are looking at the radishes from underneath, you are dead and buried. Research suggests that the origin of this idiom is actually the more universal 'root' rather than 'radish' and this particular version could well stem from literature, not folklore. It goes into a category with other synonyms for dying, such as 'Kicking the bucket', 'Pushing up the daisies', or 'Meeting your maker'. There is a brilliant *Monty Python* sketch worth referring to in this instance, as it can likely provide you not only with a good laugh but also a multitude of such synonyms. Try searching 'Monty Python Dead Parrot' online.

DIE RADIESCHEN VON UNTEN ANSEHEN

to look at the radishes from underneath

Qp

ENGLISH

We tell small, petulant children to 'mind their p's and q's,' but why? It's essentially a gentle warning to be on your best behaviour and it originates from the time of the printing press, which was introduced around 1440. One of the most important happenings of the last millennium, the printing press entirely changed the world of books, news, and how we disseminate ideas. Early printing presses had a process that required the type to be laid out back to front, which meant the lowercase 'p' and the lowercase 'q' looked exceedingly similar in certain fonts, especially less elaborate ones. In turn, this expression arose as a warning to those people setting the type – a warning that they had to be extra careful with these two letters, as one mistake would mean a misspelled word or a nonsensical sentence.

Mind your P's and Q's

HINDI

There is a well-known philosophical question: If a tree falls in the forest and no one is around to hear it, does it make a sound? We have been teased for centuries by philosophers asking such questions, causing us to ponder our apparent observations and humanity's understanding of reality. This Hindi expression is getting at much the same thing, but can be much better applied to modern-day life. It asks whether something has worth if nobody is there to witness it, whether something (such as a dancing peacock) has to be in the public eye in order to be acclaimed or acknowledged. But perhaps the dancing peacock doesn't mind, and perhaps he doesn't need an audience – maybe he is content to dance alone.

जंगल में मोर नाचा किस ने देखा ?

who saw the peacock dance in the jungle ?

SWEDISH

Somebody sliding in on a shrimp sandwich has likely had it very easy and may not have had to work hard to get where they are. It is similar to the English expression 'Being born with a silver spoon in your mouth' (a silver spoon is synonymous with wealth, especially the inherited kind), and the phrase carries connotations of said wealth not being deserved or appreciated. It's not known how often privileged Swedes are actually gliding about on shrimp sandwiches, but we shouldn't put it past them; such sandwiches have long been an integral part of their culture, and famous Swedish chef Leif Mannerström once described the open-faced shrimp sandwich as a 'food for the gods'.

INDONESIAN

This, as one might expect, is a way of multitasking, of doing more than one thing at the same time. If you're swimming, you may as well be drinking water. The English equivalent is 'Killing two birds with one stone' or the German *zwei Fliegen mit einem Schlag treffen*, meaning 'To kill two flies with one swat'. Of course, most water in which we swim isn't suitable for drinking, and it may actually be wiser to keep your mouth closed: Indonesia is the fourth most populous nation in the world, but over forty million people there don't have access to clean water. While Indonesian is actually one of the most widely spoken languages in the world, it is not the mother tongue of the majority of Indonesians; rather, it is just one of over seven hundred indigenous languages.

SAMIL BERENANG, MINUM AIR

while swimming, drink water

DUTCH

This Dutch expression perfectly encapsulates the condition of being neither here nor there. It could be used to describe that awkward phase children and teenagers have to go (and grow) through, but it can also be applied to other things. So, in addition to people, you could reasonably apply it to a not-quite-full-enough meal, a meagre pass in a game of football, or even while looking at potential new flats. A piece of writing could be 'too small for a tablecloth but too big for a napkin' if it is too short for a book but too long for publication as an article. Even books written about the Netherlands' actions during World War I note the expression, quoting a Dutch liberal politician called Willem Hendrik de Beaufort, who used the phrase when asked about an alliance between the Netherlands and Belgium. All in all, it's exceedingly versatile, whether you are talking about sport, politics, or really any other segment of daily life.

TE KLEIN VOOR EEN TAFELLAKEN EN TE GROOT VOR EEN SERVET

too small for a tablecloth and too big

for a napkin

MANDARIN

Without context, the expression, 'Horse horse, tiger tiger' doesn't have much meaning, but it's used to mean 'so-so' – not fantastic but not awful, mediocre. Words to mean 'so-so' are found in many languages, like French (*Comme ci, comme ça),* Icelandic (*Svona svona*), and Polish (*Tak sobie*). The origin of the Mandarin version lies in a story about a painter who painted a half-horse, half-tiger – nobody bought it, or even particularly liked it, seeing as it was neither one thing nor the other.

There is some concern that Chinese and English are becoming too mingled, and that Chinese won't remain 'pure' if English words keep moving into the Chinese language and vice versa. But languages are like porous membranes, and words go back and forth, here and there, migrating from one side of the Earth to the other.

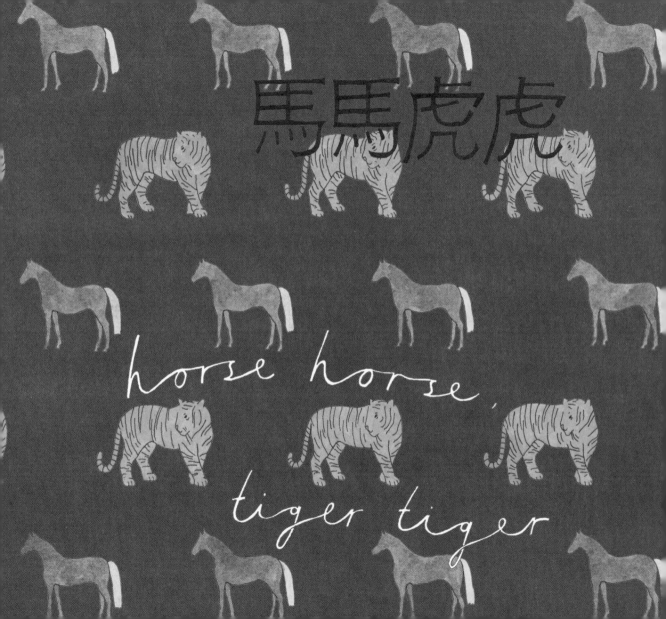

馬馬虎虎

horse horse,
tiger tiger

KASHMIRI

This saying often finds its feet in the world of politics and is frequently used to deprecate failing governments or institutions. It is reminiscent of the English expression 'Going to the dogs', which has a similar meaning but perhaps a more versatile application. The Kashmiri idiom is written in Roman script here, and this can be used generally, but Kashmiri is formally written in Sharada, Devanagari, or Perso-Arabic script. Kashmiri is an official language of India – with around five and a half million speakers – spoken mainly in the Kashmir Valley in Jammu and Kashmir in northern India, although there are also large numbers of Kashmiri speakers in Pakistan. Kashmiri is well known for its literature, as it's the only Dardic language that has an established literary tradition, and its literature dates back over 750 years – roughly the same as that of modern English.

VIRVIN NAAOW TO CHIRVIN DÉL

a drifting boat with the bark peeling off

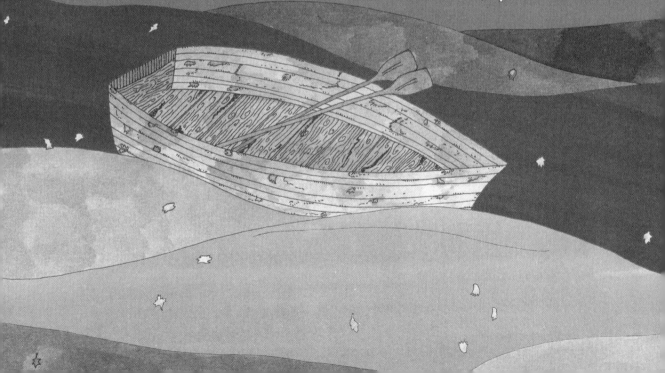

IRISH

If you're on the pig's back, you're feeling pretty good, great in fact – doing well, living large, that sort of thing. It means you are in a happy, prosperous place in your life. This Irish saying can be found from the seventeenth century onward, and the English version appears in written texts from the nineteenth century. There seems to be little connection between 'on the pig's back' and 'piggyback', or between 'on the pig's back' and 'high on the hog' (a similar-sounding American saying that means to live luxuriously, even beyond one's means). So, although there isn't much apparent connection between these pig-related sayings, it's not really surprising that pigs crop up so frequently in expressions because of our close, centuries-old farming relationship with them.

Tá mé ar muin na muice

I'M ON THE PIG'S BACK

AUSTRALIAN ENGLISH

Australians are extremely keen on their colloquial slang, which could fill a book itself (and has already done so, many times over). In this instance, the saying is a simile often used as a farewell when one is leaving a place, and leaving a place fast. It plays on the meaning of the word 'off', so it can also be used in a more obvious way, to describe something that has gone rotten or has an especially terrible 'off' stink – even a deal gone bad or a joke gone worse. To use it in a sentence and sound reasonably authentic, try something like: 'Mate, it's too warm out here – I'm off like a bucket of prawns in the midday sun.'

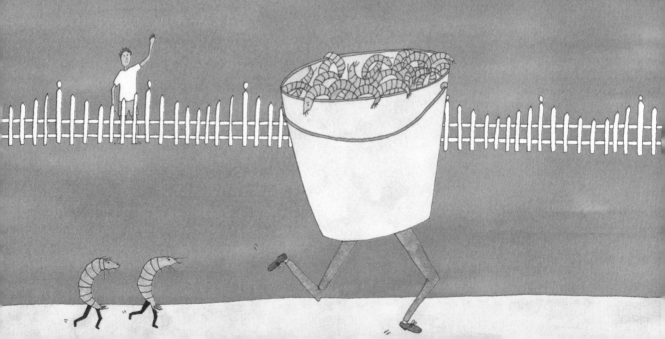

HEBREW

This is, more or less, the Hebrew version of 'Out of sight, out of mind', but instead of speaking about the mind, it speaks of the heart. It suggests that if you don't have immediate access to a person, if you don't see them every day or if they are far away, then you will not think of them as often and they will not so easily remain in your heart. This rather contradicts the old wisdom of 'Absence makes the heart grow fonder'. Why would it be true that if something is not within your direct line of sight, you will inevitably begin to forget it? But perhaps this is true – it is often said that our eyes can be bigger than our stomachs, and if that's the case, maybe our eyes are bigger than our hearts, too.*

*I think not.

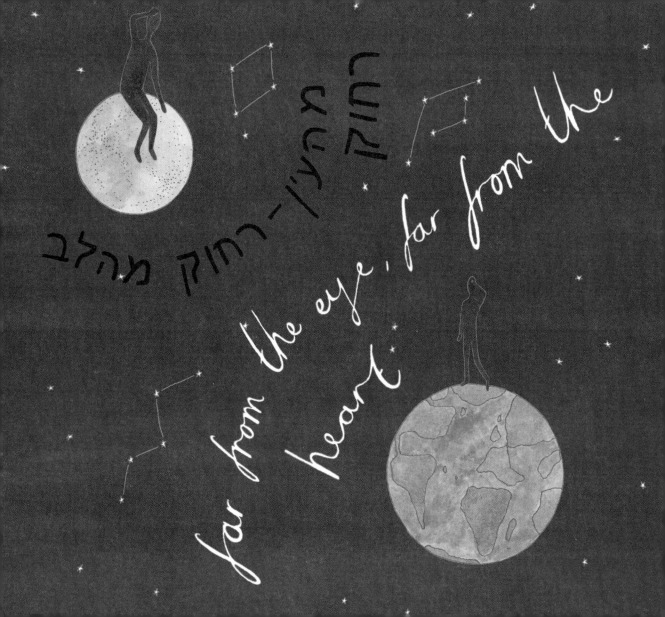

MALTESE

This saying is simple. If your eye goes with you, it means that you have fallen asleep. As a language, Maltese is spoken by half a million or so people on the island of Malta, and also by thousands of emigrants who left for countries such as Australia, Italy and the United States. Around half of the Maltese vocabulary is derived from Italian and Sicilian, while English words make up as much as 20 per cent of the language, so it's a bit of a jumble (it's also the only Semitic language written in Latin script). When falling asleep, whether it is in Malta, Finland, or Timbuktu, it is important to take your eyes with you – failure to do so will likely result in a night of sleep that's neither restful nor regenerative.

ITALIAN

This expression is something Italians use in the same way English speakers would say 'Break a leg' – a sort of 'Good luck!' with a hearty pat on the back as they push you onstage and into the bright, blinding lights. If someone wishes you good luck in this Italian manner, the correct response is 'May the wolf die!' which is *Crepi lupo!* or even just *Crepi!* in Italian.

It means you are now ready to go off and conquer all the beastly tasks that no doubt lie in wait for you. If you do happen to be readying yourself for a daunting or seemingly impossible challenge, perhaps consider that it's likely not going to be as bad as literally walking into the mouth of a wolf, and as a consequence, you may find yourself feeling slightly better.

ARABIC

You know the English phrase, 'You win some, you lose some'? This is (more or less) the Arabic version but with the addition of honey and onions and therefore, potentially, far more delicious. It's really a very reasonable outlook to take on life, the idea that sometimes, happily, things will go our way and other times will go spectacularly wrong, and that happiness probably lies somewhere between the two. It's somewhat reminiscent of the Japanese aesthetic *wabi-sabi*, which centres around acceptance of the imperfect and the ephemeral. After all, life is very irregular – it's often strangely shaped and fraught with unhelpful timings, but then it is also painfully beautiful, and the universe actually conspires to help you in every way imaginable. So if some of the days are onions, that's fine by me.

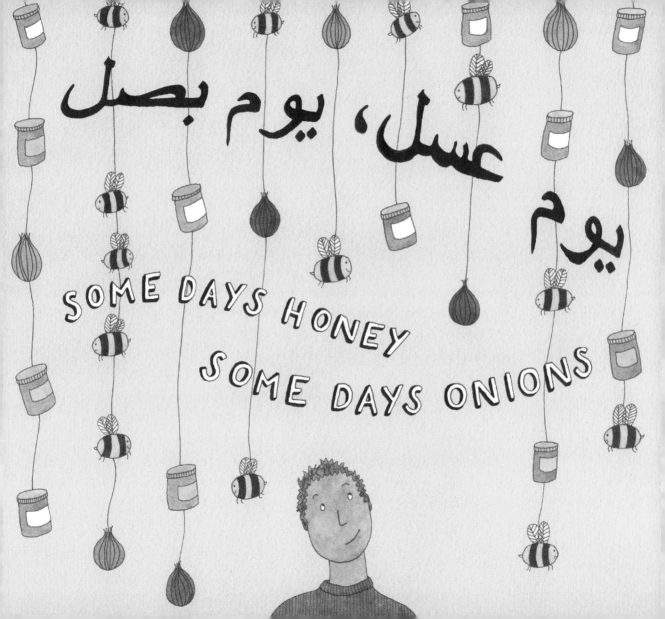

G A

Ga is the name of both a tribe in Ghana and its language (it's one of sixteen official languages spoken in the country), and this proverb says that the person fetching the water (who traditionally would be walking long distances to reach a well or a river) is the one most likely to break the earthenware pot. It's a roundabout way of suggesting that if you don't have anything helpful to say or don't plan on making any kind of contribution, don't then criticise someone who's trying to get things done, and in doing so may make genuine mistakes. Of course, if you dramatically reduce your efforts and decide never to leave the house again, then you will also dramatically reduce any potential mistakes or errors, but that rather takes the unexpected and the fun out of things, don't you think?

faa yalo dzwee gbe

THE ONE WHO FETCHES THE WATER IS THE ONE WHO IS LIKELY TO BREAK THE POT

FINNISH

When travelling as a rabbit, one is doing so without paying the fare – as a stowaway, sneaking onboard a train, bus, or ship, and likely staying as quiet and nondescript as a rabbit in the hope that nobody notices. It's a thrilling but risky business – even for those with twitchy noses and cottontails – and so not really recommended. Perhaps the idiom refers to a rabbit because it wouldn't be tall enough (even standing on its back legs) to reach the ticket barriers, so can hop straight on through and cross whichever cities or oceans it pleases. As early as 1946, people were hiding inside the wheel wells of aeroplanes and journeying far and wide (although the success rate was below 24 per cent). But it's not just humans who make use of this classic stowaway technique – animals can be excellent accidental explorers, and in 2013 a cat survived a flight from Athens to Zürich in the front undercarriage of a plane.

Matkustaa jäniksenä

TO TRAVEL AS A RABBIT

JAPANESE

To wear a cat on your head is to pretend to be innocent, to feign
sweetness in order to mislead others into thinking that you are altogether
angelic when in fact you may be up to no good. With a cat on your head,
you are keeping your claws hidden as well as your true personality. So this
is similar to the English saying, 'A wolf in sheep's clothing', which alludes
to the fact that cats – even after tearing up your curtains – tend to look
utterly innocent. Japan is known to be a little obsessed with cats
(in folklore they symbolise good fortune), and consequently there are
many wonderful Japanese cat-related idioms, slang terms, and sayings:
a cat blowing tea, a cat playing with a walnut, an umbrella to a cat,
cats and rice paddles . . . the list goes adorably on.

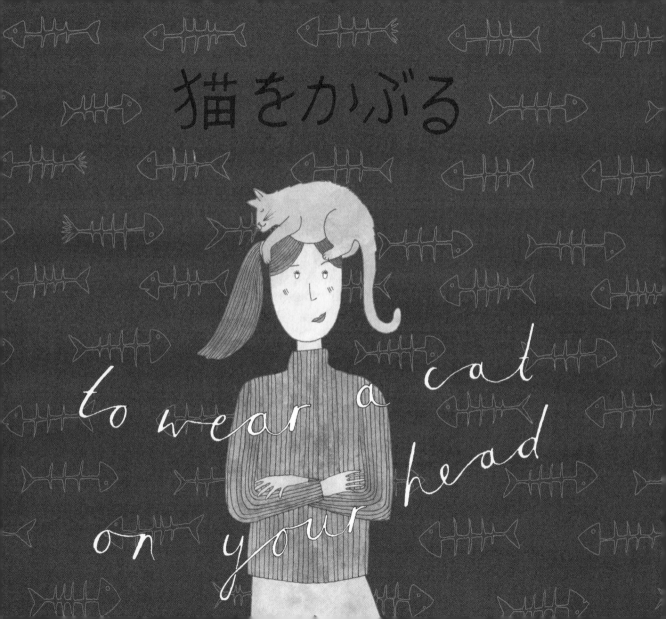

FRENCH

This idiom from the land of wine and cheese and all things chic is used in conversation when you're going horribly off topic while trying to underline something and need to assure those you're talking to that you are getting back to the aforementioned point. It's a sort of 'But I digress . . . so let us now return to our sheep' for when you've wandered into the conversational wilderness but plan on finding a way back – perhaps it was all part of your plan to appear cultured and worldly. As an idiom, it evokes images of lost, absentminded shepherds and self-assured sheep who are the ones calling the shots. Its origins are in the fifteenth-century French comedy, *The Farce of Master Pierre Pathelin*, which involves cheap cloth, stolen sheep, feigned delirium and a lot of confusion.

JE RETOURNE A MES MOUTONS

i'm returning

to my sheep

ITALIAN

If a head is full of crickets, it's full of what some would call nonsense – of whims, of fantasy, of strange ideas and desires and flights of fancy. Any head is susceptible to these crickets, and sometimes they can make us do crazy-wonderful things. After all, people who dream, even about nonsensical things, are often the ones who will change that which needs to be changed. They might have impossibly high ambitions or unrealistic plans, which link to the ridiculously high leaps that crickets make. But it is perhaps worth remembering that with a head full of crickets, there is a risk of such incessant chirping and chatter that one could not even hope to think straight.

avere grilli per la testa

TO HAVE A HEAD FULL OF CRICKETS

SPANISH

This simile is perhaps easy enough to understand without explanation, although it would depend on both the octopus and the garage. It means to feel confused and out of place, overwhelmed by your surroundings.

It's practically identical in meaning to the English 'Like a fish out of water', and interestingly, both involve aquatic animals in out-of-the-sea situations. Although it turns out this simile may not have a leg (or eight) to stand on, as recent research suggests that octopuses are intelligent, emotional creatures with wildly differing personalities. The octopus has the largest brain of any invertebrate, and its 130 million neurons are not only in its brain but also in its arms – its suckers can taste as well as feel. But the most breathtaking possibility is that octopuses can actually see with their skin. So a garage? Likely not a problem.

ENCONTRARSE COMO UN PULPO EN UN GARAJE

to feel like an octopus in a garage

YIDDISH

As with species, languages evolve and diverge when speakers are separated in diasporas. Yiddish, the historical language of the Ashkenazi Jews, evolved from Middle High German with bits of Russian and Hebrew blended in, and is perhaps one of the most interesting and poetic languages of all. This widely used idiomatic phrase essentially means 'Stop bothering me!' and the imagery comes not only from someone physically banging on a kettle but also because the lid of a traditional kettle moves up and down as the water boils, loudly making nothing but meaningless noise. It's thought that this Yiddish expression might partly stem from the Russian expression 'To hit someone on the teakettle', because the word for 'kettle' in Russian is also a colloquial word for 'head'.

TIBETAN

If you give a green answer to a blue question, you are giving an answer completely unrelated to the question that was actually asked. Excellent examples of this are often found in politics when candidates or politicians are asked about scandals and failed policies, and they swiftly evade any trouble by giving a nonsensical answer, leaving everyone in the room a bit confused. They get very practised at it – think of it as an art form that can be studied and eventually excelled at. But unrelated answers also occur when you have simply forgotten what the question even was, or when you just don't know the answer and your pride doesn't allow you to do much apart from possibly burst into awkward song.

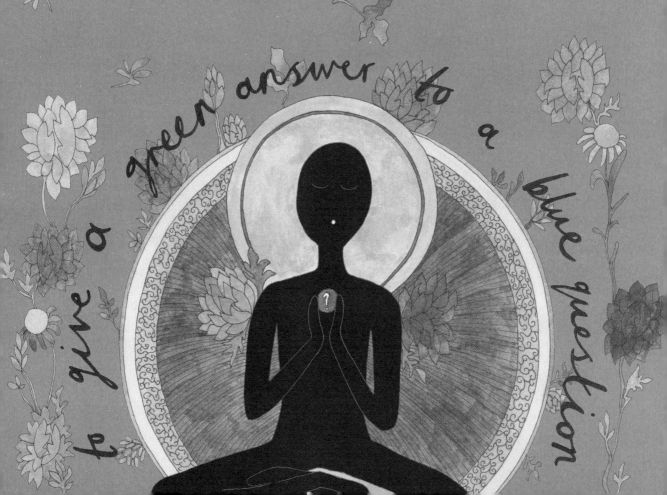

MONGOLIAN

This is a rather lengthy and gentlemanly way of blessing somebody after they sneeze. While in English a 'Bless you' or sometimes the German *Gesundheit* is considered the usual, in Mongolia something so simple doesn't always cut it. So instead, you also express a sincere hope that the sneezer's moustache will grow like brushwood. Some sources suggest that it isn't really used nowadays (especially not when a woman sneezes), and just a 'God bless you' gets the message across, but others employ the full moustache blessing as the expected response. For those who are wondering, 'brushwood' either refers to branches that have been broken or cut off, or an area of dense undergrowth – some combination of these would make for an excellent moustache.

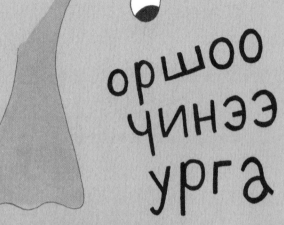

бурхан
бутын
сахал

оршоо
чинээ
урга

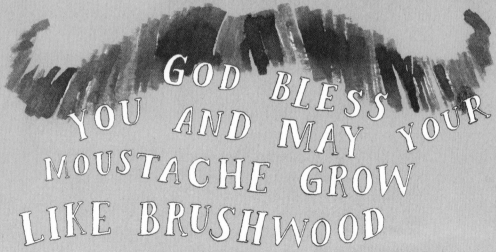

GOD BLESS
YOU AND MAY YOUR
MOUSTACHE GROW
LIKE BRUSHWOOD

BULGARIAN

Little by little, greatness – that's essentially what this Bulgarian proverb means. Little by little, humans can accomplish almost anything, so it's fine to start your ascent to greatness with just a drop or two of inspiration; you'll get there eventually and then you'll have a whole lake to splash about in. Sounds rather wonderful, doesn't it?

It's really quite astonishing that lakes, rivers, and oceans cover 70 per cent of our planet, especially since scientists still don't really know where all the Earth's water came from. But doesn't it just make you crave the smell of cool rain on red, sunbaked earth? In fact, there's a word for that – 'petrichor', an English word that describes the sweet, earthy scent that fills one's nostrils after rain has fallen on parched soil.

капка по капка-
вир става

drop by drop, a whole
lake becomes

ROMANIAN

Many idioms translate oddly, but Romanian ones can be exceptionally confusing when translated into English, and without an explanation, we wouldn't have much hope of understanding them. But my, are they wonderful. 'To pull someone out of their watermelons' is to drive them crazy, a bit nuts. While the rest of us are surprised, Romanians' faces fall off (*I-a picat fața*); they do not lose their tempers but instead, their mustard will jump off (*Îi sare muştarul*). They will not tell you to stop wasting time but to stop rubbing the mint (*A freca menta*), and a Romanian will not lie to you but will sell you doughnuts (*Vinde gogoşi*). Static on your TV in Romania? 'The TV has fleas!' (*Televizorul are purici*). And instead of catching your breath? You are pulling your soul (*A-şi trage sufletul*). The list goes on in a fascinating fashion.

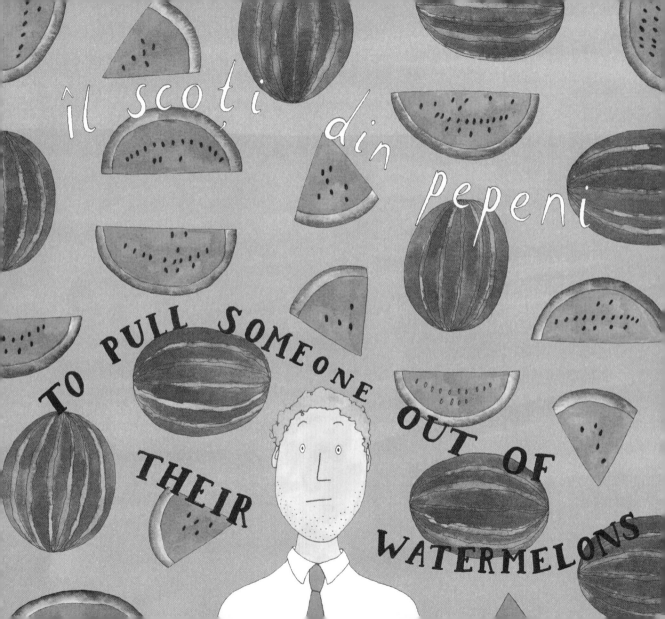

BRAZILIAN PORTUGUESE

As it turns out, it's mainly the black caiman that calmly terrorizes the Amazon rainforest, munching on a wide variety of fish, birds and mammals (you won't find alligators or crocodiles in the Amazon, unless perhaps a couple of specific types of the latter have ended up there by accident). But when the caimans are smaller, they are frequently preyed upon by piranhas. And although this saying carries a useful message – one along the lines of 'If you're heading into unsafe waters, take extra precautions' – it doesn't actually ring true in the animal kingdom: crocodilians are almost never on their backs while in the water or on land except when fighting others or their prey – they never remain sunny side up by choice.

em rio tem piranha,
jacaré nada de costas

IN A RIVER
FULL OF PIRANHAS, CAIMAN
SWIM ON THEIR BACKS

UKRAINIAN

When used in conversation, this expression means that you don't know anything about what is being said – that it's not your business. It doesn't necessarily have to be a cottage; the literal translation says 'hut', but we can suppose most other types of abode would be acceptable places to inhabit. It's a very succinct way of saying that 'My hut is on the other side of the village; I don't know what you're talking about'. For most Ukrainians, it seems that inquisitiveness doesn't come so naturally (unless there are foreigners involved), and they tend towards being very respectful when it comes to privacy and not sticking noses in places they shouldn't necessarily be.

CZECH

All in all, this sounds like a pretty bad idea. Unless you have otherworldly snake-patting abilities, you should not be trying this at home. The saying is the Czech equivalent of 'to walk into the lion's den' (also a bad idea) – to pat a snake with bare feet is to willingly enter into what is almost certainly a terrible situation, even a life-threatening one. But take some comfort in the fact that the Czech Republic doesn't actually have that many snakes, relatively speaking. Grass snakes, dice snakes, smooth snakes and Aesculapian snakes are nonvenomous and will likely be more frightened of you than you are of them. The only poisonous snake to worry about in the Czech Republic is the adder (*zmije* in Czech), which, if you are a healthy, strong sort of person, won't do you much damage anyway – their bites are painful but rarely fatal.

HLADIT
BOSOU
HADA
NOHOU

to pat a snake
with bare feet

HINDI

The English equivalent of this would likely be 'Empty vessels make the most noise', and both mean that those who have little real knowledge tend to make a great song and dance about it all; they tend to proclaim things loudly and jump about or wave their arms in great sweeping motions, gesticulating wildly and often without cause. Frequently, those who know a lot or even those who know all (I haven't met any such people thus far), are the calm, quiet, silent ones. Sometimes the important message can be conveyed with only a few words, and sometimes, when the moment is considered and the stars have aligned, you can say everything within a silence.

अधजल गगरी छलकत जाए

half - filled pots splash more

RUSSIAN

If a Russian tells you he's going to show you where the crayfish spends the winter, he is not going to take you on a David Attenborough-like nature adventure and finish up with a funny crustacean anecdote. Actually, he is going to show you what's what, to give you a piece of his mind, and you'd better watch out. There is a German threat with the same meaning and a similarly aquatic literal translation: to show someone 'where the frog has curls' (*Wo der Frosch die Locken hat*). Crayfish (also known as crawfish or crawdads) cannot tolerate freezing water conditions, so they mostly live in rivers with fresh flowing water and move to deeper waters if things start to get too cold and frozen close to the surface. Crayfish already know where to spend their winters – you don't have to show them.

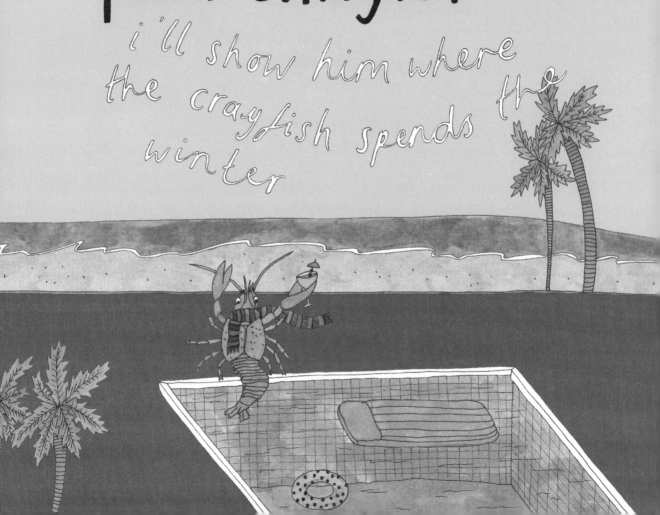

GERMAN

The bear (widely acknowledged to be a tap-dancing one, because *steppt* is a German dialect word for tap-dancing) is where the party can be found. More generally, the place where the bear dances has a lot going on, has excellent vibes and is the place to be – a hot spot of sorts. The saying is thought to date back to the Middle Ages, when travelling circuses would occasionally pass through remote, quiet farmland and liven things up a bit for the locals. Back when dancing bears were a popular and accepted attraction (animal rights activists weren't really around between the fifth and fifteenth centuries), there would be music and merriment and a jaw-dropping awe before these large, fur-covered creatures trained and forced to entertain. It might be worth noting that these creatures also happen to dance perfectly wonderfully in the wild when nobody is watching.

DA STEPPT DER BÄR!

the bear dances there!

DANISH

If it's blowing half a pelican, it's pretty darn windy. You may be wondering
if Denmark gets awfully blustery and people and cats and dogs get blown
about all over the place. Well, yes. Although Denmark's climate is actually
pretty mild considering its northern latitudes (it doesn't get much colder
than 0°C/32°F or much warmer than 17°C/63°F), the country is surrounded
almost entirely by sea, and the strong west winds that blow mean that on
some days Denmark's wind turbines can generate as much as 140 per cent
of their electricity demands. So this idiom makes a lot of sense, not least
because one of the largest members of the pelican family – the Dalmatian
pelican – lives in Denmark. These giant birds have a wingspan of over
11 feet and are very, very heavy considering that they are able to fly.

TURKISH

The idea behind this saying is that we begin to resemble the company we keep, and that we mature by learning from those around us. The motivational speaker Jim Rohn once said, 'You are the average of the five people you spend the most time with', and if you believe him, then you should be thinking carefully about who those people are. This is mostly because bad behaviour and general unpleasantness can be very contagious but also because, if you look closely, many 'bad' people have become bad through the company they keep. Whether we like it or not, we – our decisions, our self-esteem, our thinking patterns – are greatly influenced by those closest to us, whether they be grapes or people.

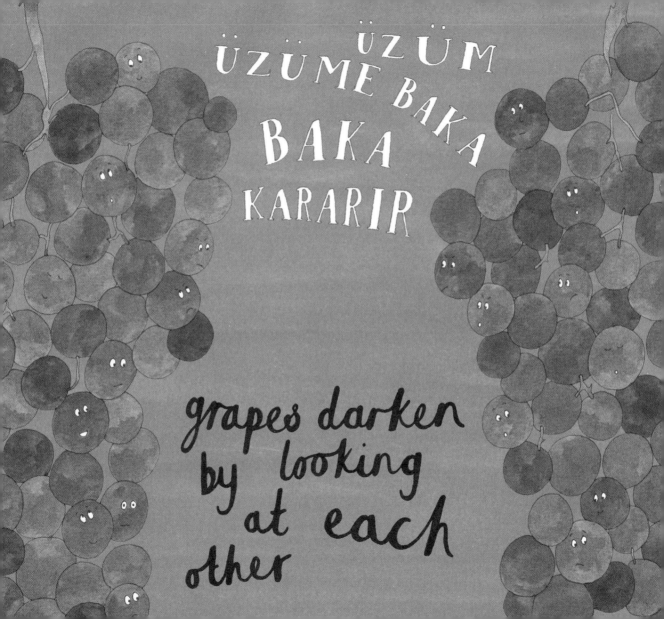

ÜZÜM
ÜZÜME BAKA
BAKA
KARARIR

grapes darken by looking at each other

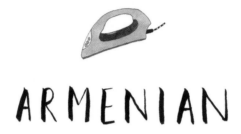

ARMENIAN

This idiom essentially means 'Stop annoying me!' and can be used with gusto in a situation where someone keeps asking you irritating questions or generally just won't take the hint and leave you alone. Be on the lookout for anyone with a gleam in their eyes and a quizzical expression, for those are typically the people who insist on asking you either meaningless yet excited questions, or ones about the theory of everything that will likely make your head hurt as if someone were ironing it. Ironically, perhaps, doing some ironing would be a good way to calm down again after such an intense exchange – the soothing sound of steam and the smell of fresh cotton.

NORWEGIAN

Also found in some other Scandinavian languages, this idiom has a variety of accepted usages. For many, it is the equivalent to the English 'To get caught red-handed', or 'Getting caught with your trousers down'. It is also commonly applied to a person who is not actually guilty of anything but still gets caught in an unfortunate or undesirable situation. There also seems to be some usage when referring to someone who has been left completely stumped or who has had their plans dashed. The idiom has an alleged origin in a story about a post office employee in olden-day Denmark who had stolen money: he was convicted after strands of his beard were found in the safe that he had denied ever having touched. So it may be worth noting at this point that if you are a bearded person, your criminal career could potentially be compromised.

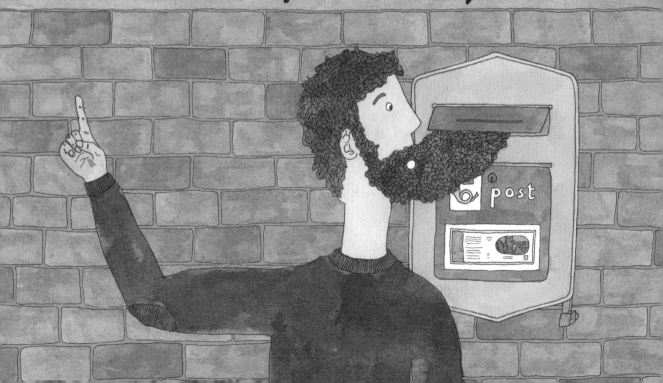

POLISH

If something is neither your circus nor your monkeys, then it is not your problem. Colloquial and slightly humorous, this saying can also be used in a disapproving tone to mean that you are 'Washing your hands' of an issue. In Poland, it is commonly used in this way, as a giving-up-in-discussion phrase. For example, if you're trying to convince someone they have a terrible idea and they just won't listen, you can say that it's 'not my circus, not my monkeys, so do whatever you want' and wander off nonchalantly. The general consensus seems to be that it's a more modern – but no less charming – phrase rather than an old proverb from Polish folklore.

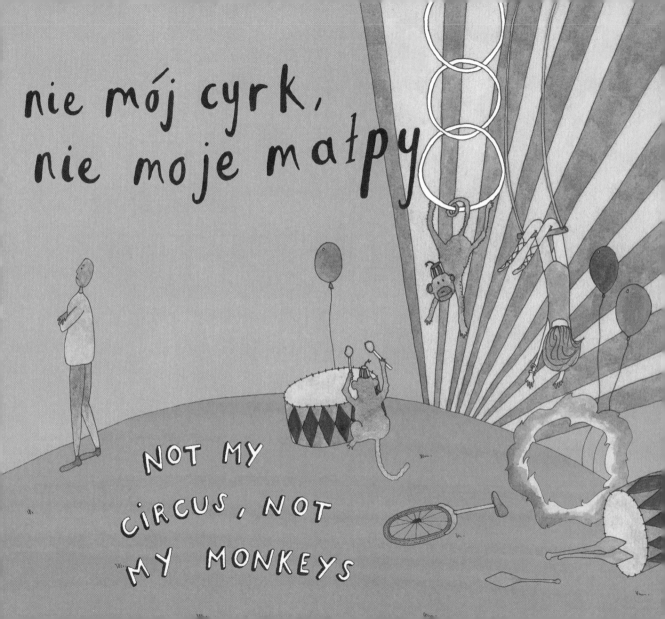

FARSI

Slightly morbid but no less intriguing, this is just one of many Farsi sayings that makes little sense when translated into English. Its literal translation would put most people off at first sight (or rather, first bite), but it is actually a term of endearment for native speakers. This saying is also found in other Persian dialects, though with slightly altered spelling. *Jeegaretō bokhoram* is a way of expressing deep affection and love and would usually be used only when speaking to close loved ones, like family members or dear friends. Its meaning is along the lines of 'I would do anything for you', 'You are my heart', or 'I love you so much, I could just eat you up'.

jeegaretō bokhoram

I WILL EAT YOUR LIVER

SWAHILI

The Swahili people are an ethnic and cultural group living in the African Great Lakes region, and Swahili is a Bantu language and lingua franca spoken by as many as 150 million people (although only five to fifteen million speak it as their first language). This proverb aims to teach that even after a long and arduous journey, the water of the sea is never going to quench a person's thirst. Additionally, parallels can be drawn between the waters of the ocean and the wealth of rich people, who do not usually provide for the poor – such wealth seems a waste from the poor man's perspective (it is of no use to him since he can only look and contemplate). The people living in the Great Lakes region, around lakes such as Lake Victoria (the largest lake in all of Africa), are thousands of kilometres from the Indian Ocean, and they know that the water of the lake is sweet compared to the rough, salty waters of the ocean.
The proverb is also found in French: *L'eau de la mer, c'est pour regarder.*

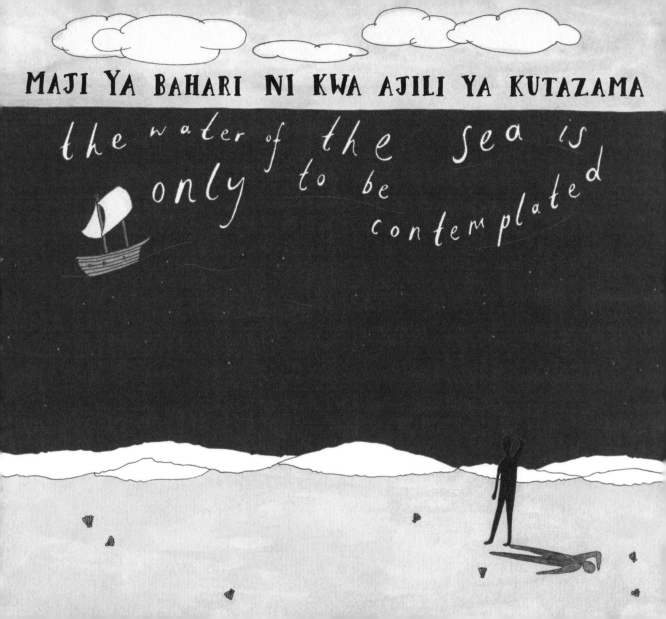

MAJI YA BAHARI NI KWA AJILI YA KUTAZAMA

the water of the sea is only to be contemplated

COLOMBIAN SPANISH

Idioms are peculiar expressions that cannot be understood from the individual meanings of the words that comprise them – they are more than the sum of their parts. This one, believe it or not, means to be madly in love. Let us speculate: postmen usually do lots of walking about with letters and parcels and whatnot, so we can reasonably deduce they need good shoes – tough boots, perhaps. They also need good socks, which may or may not wriggle down a postman's foot as he strolls purposefully throughout the neighbourhood; hence, the sock may well end up somewhere at the toe end of his boot, swallowed. It is similar to the way, we can suppose, that a person may be completely swallowed up by feelings of love – overtaken by love, ingested by love, that sort of thing.

IGBO

This particular proverb poses a rhetorical question along the lines of 'Who is able to explain this puzzle?' Igbo is one of Nigeria's four official languages and has about twenty-four million speakers in Nigeria and Equatorial Guinea. But, with over twenty different dialects, things can get a little confusing. Igbo proverbs are central to Igbo culture – and an important way of propagating it – and so proverbs can be found scattered throughout formal, familiar, and everyday speech. According to the Igbo Community Association of Nigeria, Igbo rarely bother to explain their proverbs and listeners are expected to figure things out themselves. Chinua Achebe, the late Nigerian novelist and poet, once described Igbo proverbs as 'the palm oil with which words are eaten'.

A MA KA MMIRI SI WERE
BAA N'OPI UGBOGURU?
who knows how water
entered into the stalk of
the
pumpkin?

FILIPINO

This is an interjection generally yelled by Filipinos when something surprises them, a sort of 'Oh! What's that!?' when something is a bit out of the ordinary or is entirely unexpected. Examples of such moments might include stubbing your toe, finding the shower either burning hot or icy cold, and receiving unusually great news.

Horses are actually quite surprising in themselves: they have three eyelids, can sleep standing up or lying down, certain breeds can run for over 99 miles/160 kilometres without stopping, and their memory is at least as good as that of an elephant – if you befriend an equine, he will never forget you. Lastly, if a horse has pink (rather than gray) skin and the sun is shining, he will need to wear sunscreen.

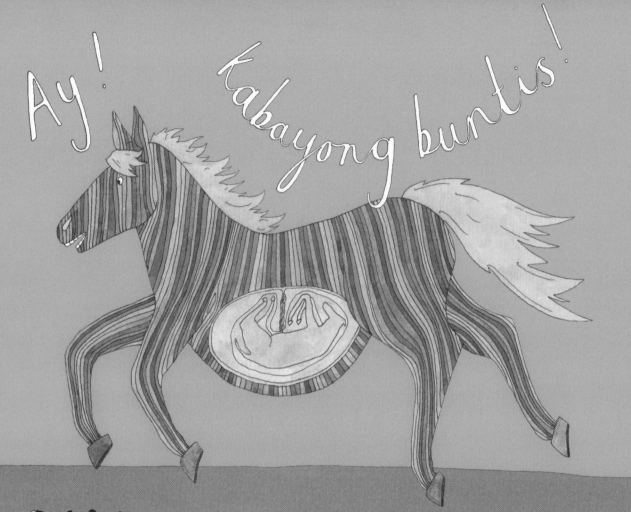

AROMANIAN

This is almost identical in meaning to the English proverb 'One swallow does not a summer make', which alludes to the clockwork return of migrating swallows at the start of the summer months and was originally taken from a remark made by the Greek philosopher Aristotle: 'One swallow does not a summer make, nor one fine day; similarly one day or brief time of happiness does not make a person entirely happy.' He knew what he was talking about. Both the English and Aromanian proverbs mean that a singular but seemingly significant incident or event doesn't always indicate a pattern or a trend – so don't go getting ahead of yourself and leap to conclusions about the planting season and weather patterns. Aromanian is similar in some ways to Romanian – both are Romance languages spoken in Southeastern Europe – but Aromanian is influenced more by Greek rather than Slavic.

primuveară nu s-adutsi
mash c-ună lilici

ONE FLOWER DOESN'T MAKE
THE SPRING

Ella Frances Sanders is a writer out of necessity and an illustrator by accident. She currently lives and works in the city of Bath, UK, without a cat. Her first book, *Lost in Translation: An Illustrated Compendium of Untranslatable Words from Around the World*, was a *New York Times* bestseller and is now, perhaps ironically, being translated into many other languages. She still doesn't know exactly how it all happened, but things seem to be going OK.

She can be found at ellafrancessanders.com and various other social media places.

· ACKNOWLEDEGMENTS ·

This book was no less strange than the first.

I cannot not thank my no-longer-agent Elizabeth Evans, who broke my heart by moving on to new escapades just before we tied up this project – you know precisely how much you have helped me, how much you have given me. Thank you for believing so entirely in someone who didn't have a single heck of a clue what she was doing. You may not necessarily want my eternal love and gratitude, because that's weird, but you have it anyway.

Thank you to all at the Jean V. Naggar Literary Agency, which contains some of the nicest ever humans – I'm lucky to have you to scrape me off the floor when I invariably fall over, and you've all been so patient with me: thank you. An almighty thank-you to Jennifer Weltz, for persuading many other countries that they needed to translate and publish my first book, and for undertaking the task of agenting me – we shall conquer all.

To the entire team at Ten Speed Press, thank you. I may have never met you in person, but I'm sure we would have a real hoot. Thank you all for holding my hand and for letting me make another book, and thank you for the endpapers and putting up with my insistent questions about this and that and whatever else. Kaitlin Ketchum, you are an editor sent from the heavens: thank you for making this process as magical and star-filled as the last time. To Nicola Barr, Anna Redman, Rosemary Davidson and everyone at Square Peg in the UK – thank you for being closer to home.

And to my family like no other.

And to Vincent.

Thank you.

1 3 5 7 9 10 8 6 4 2

Square Peg, an imprint of Vintage,
20 Vauxhall Bridge Road,
London SW1V 2SA

Square Peg is part of the Penguin Random House group of companies
whose addresses can be found at global.penguinrandomhouse.com

Copyright © 2016 by Ella Frances Sanders
Designed by Lizzie Allen

Ella Frances Sanders has asserted her right to be identified as the author of this
Work in accordance with the Copyright, Designs and Patents Act 1988

First published by Square Peg in 2016

A CIP catalogue record for this book is available from the British Library
ISBN 9781910931264

Printed and bound in China by Toppan Leefung Printing Ltd
Penguin Random House is committed to a sustainable future for our business, our readers and our planet. This book is made from Forest
Stewardship Council® certified paper.

Sources: kzr.agrobiologie.cz, www.chinatownstories.com, www.etymologiebank.nl, secouchermoinsbete.fr, www.deutschland-feiert.de,
www.afriprov.org, mek.oszk.hu, www.icandfw.com, blogs.ei.columbia.edu, www.phrases.org.uk, virtualneko.com, www.omniglot.com,
www.wordsense.eu, afroginthefjord.com, www.quora.com, www.elephant.org.il, serbiantiger.blogspot.co.uk, inthegarlic.com,
www.spanishdict.com, interfluency.wordpress.com, *Dutch Messengers* by Cornelis Dirk Andriesse, *The Netherlands and World War*
by Hubert P. Van Tuyll Vam Serooskerken, *Dutch Foreign Policy Since 1815* by Amry Vandenbosch, *Wordbook of Australian Idiom – Aussie Slang*
by Kerrin Rowe and Carol Rowe, *The Invisible Code* by William M. Reddy, *Halima* by Mercy Ngozi Alu.